Embroidery pour le Bébe

Many thanks to:

Isabelle (and congratulations, retroactively) for her artistic (and culinary) advice, as well as for her charming graphic compositions.
Laurence from Matière active for the use of their lovely fabrics, and to DMC for the beautiful threads that they so generously provided.
Arnoldas Dambrauskas, for his font design that so perfectly evokes the look of embroidery; to Yolande Damart, who designed the little pink and blue rabbits on pages 14–15;
and to Anne-Sophie Carpentier for her invaluable assistance . . . and special thanks to all those babies who were such a marvelous inspiration!

HarperCollins books may be purchased for educational, business, or sales promotional use. For information, please write:
Special Markets Department, HarperCollins Publishers, 10 East 53rd Street, New York, NY 10022.

Published in 2013 by:
Harper Design
An Imprint of HarperCollins*Publishers*
10 East 53rd Street
New York, NY 10022
Tel (212) 207-7000
harperdesign@harpercollins.com
www.harpercollins.com

Distributed throughout the world by:
HarperCollins Publishers
10 East 53rd Street
New York, NY 10022

Library of Congress Control Number: 2012947757

ISBN: 978-0-06-222263-3

Printed in China, 2012

Embroidery, designs, and fabrication: Sylvie Blondeau
Photographs: Thierry Antablian
Editorial direction: Guillaume Pô
Editing: Christine Hooghe
Artistic direction: Isabelle Mayer
Production: Emmanuelle Laine
Translation: Elizabeth G. Heard

Embroidery pour le Bébé

100 French Designs for Babies and the Nursery

Sylvie Blondeau

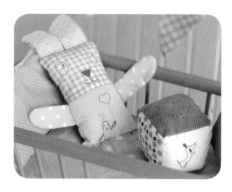

HARPER DESIGN

An Imprint of HarperCollins Publishers

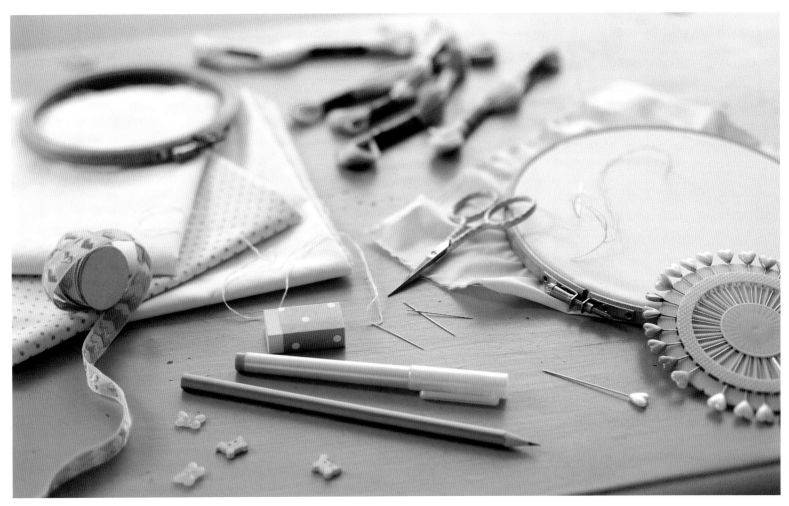

Brodez les objets précieux!

A piece of linen, a few strands of thread, and a needle—these are the only supplies you need to start embroidering! Pages 52 through 59 of this book break down all the stitches you need to know to create charming designs perfect for the precious things a little one has: first "grown-up" meals, first vacation and birthday party, favorite playthings, adventures with a beloved cuddly toy, and that snug little onesie! There's nothing more magical than watching your little one discover the world.

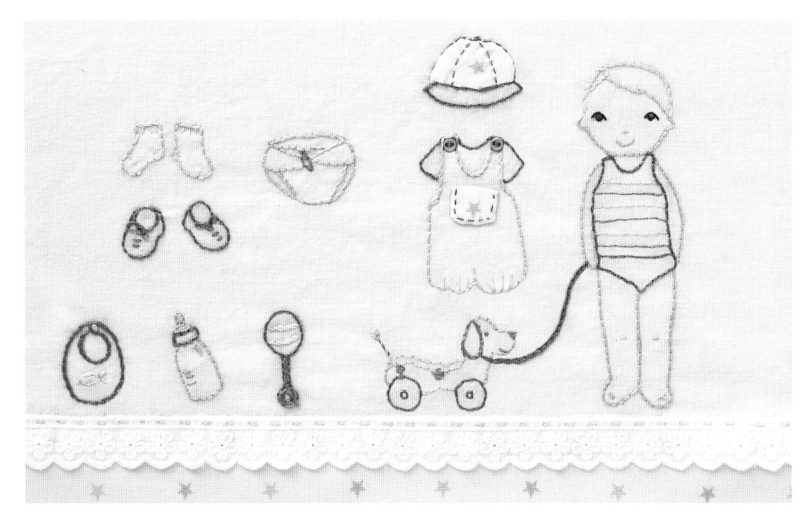

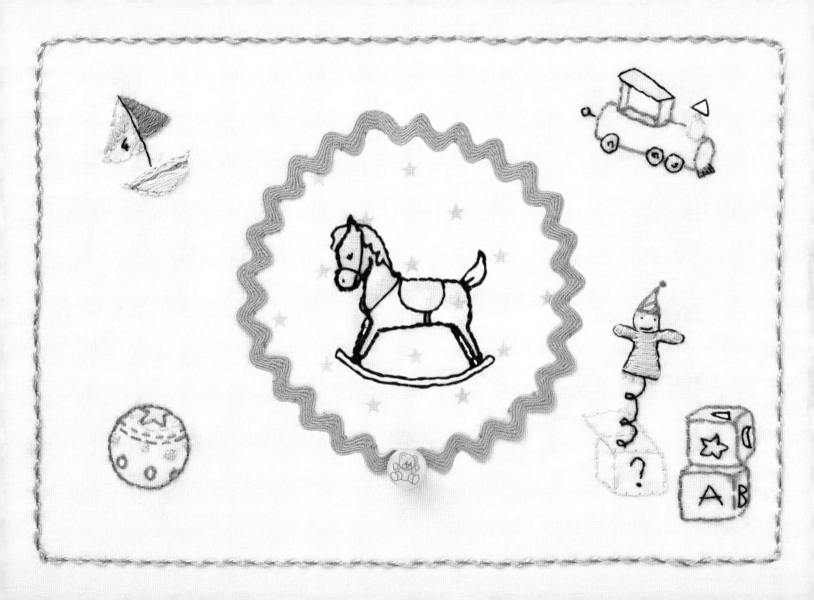

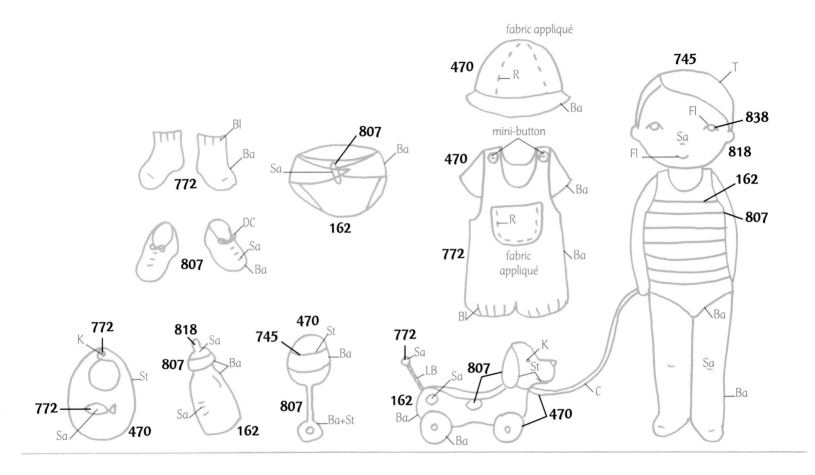

Color references: DMC Embroidery Thread (one or two strands, depending on the photograph).

Stitches used: abbreviations on the flap at the end of the book, instructions on pages 54–59.

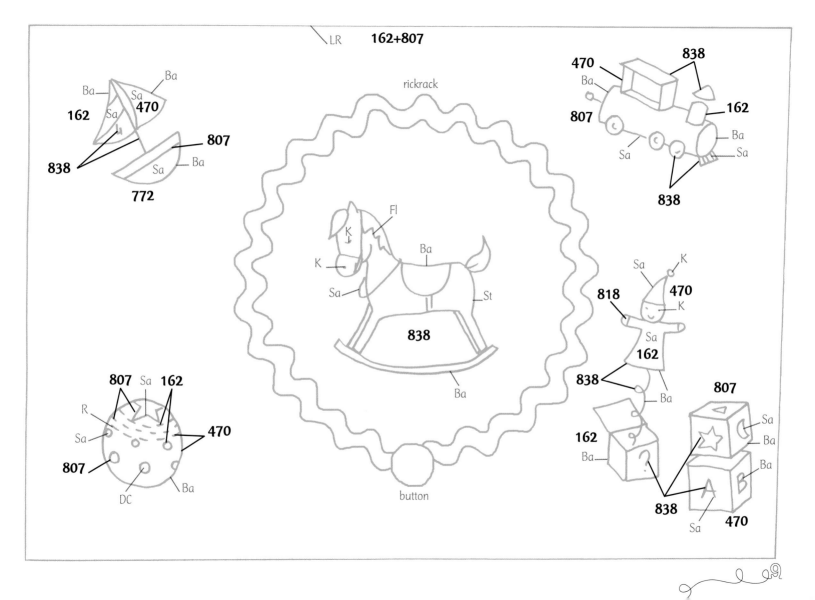

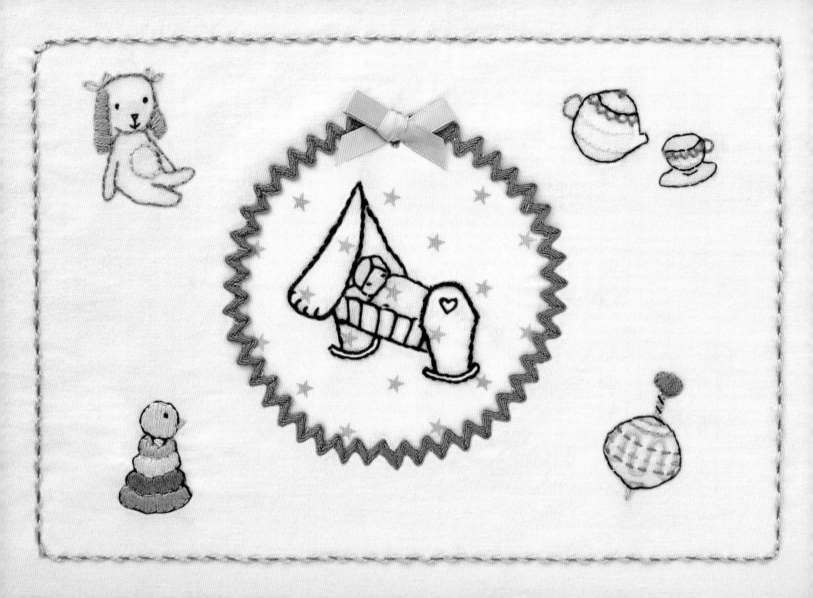

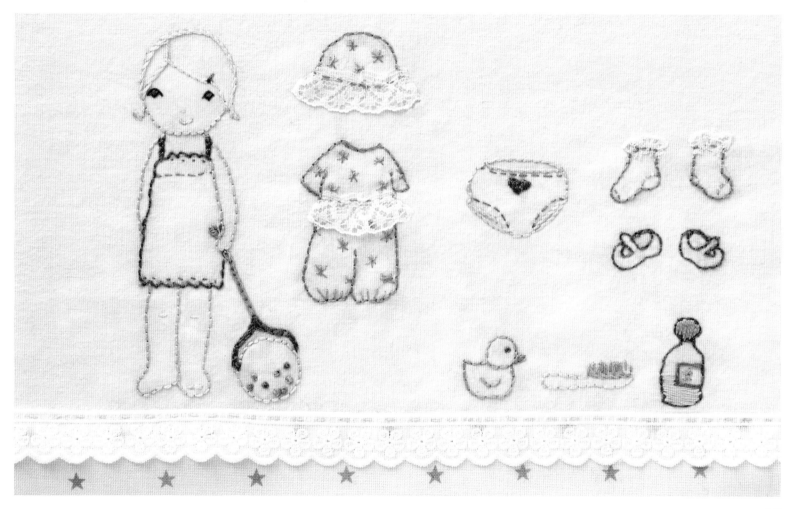

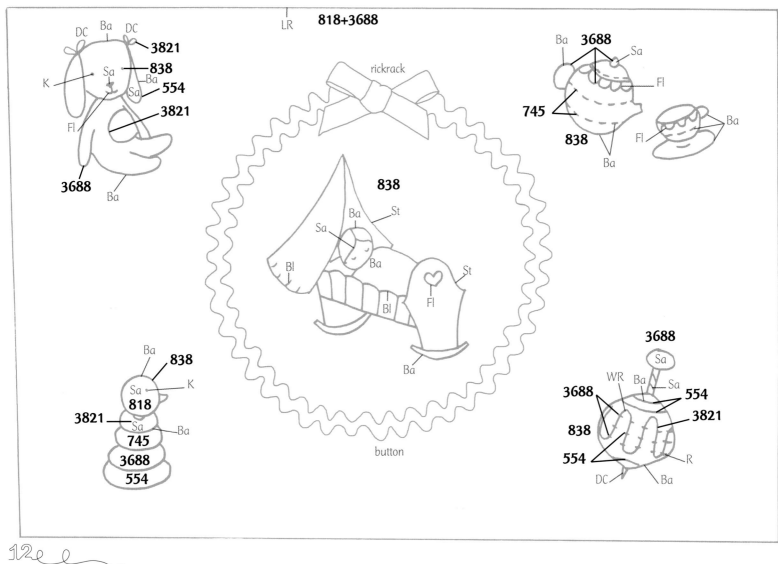

818+3688

rickrack

838

button

12

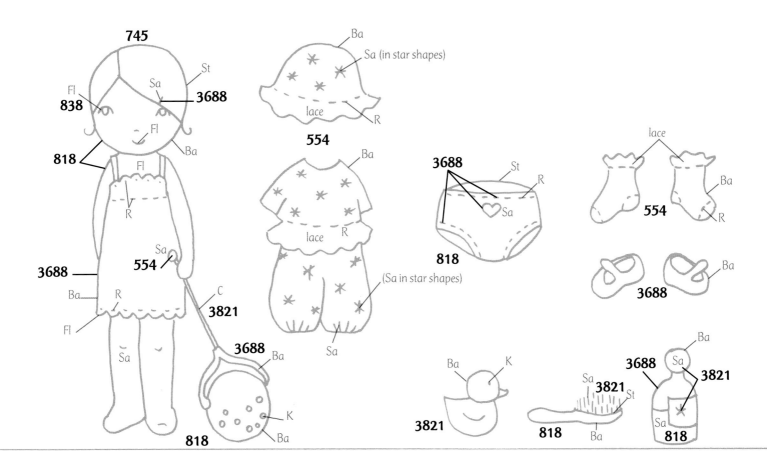

Color references: DMC Embroidery Thread (one or two strands, depending on the photograph).

Stitches used: abbreviations on the flap at the end of the book, instructions on pages 54–59.

13

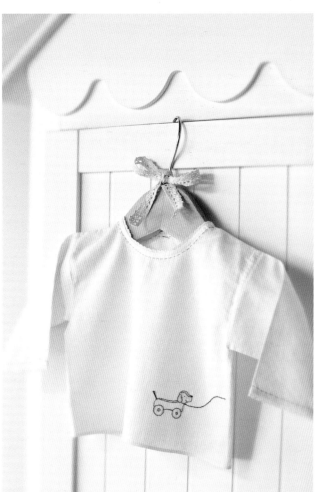

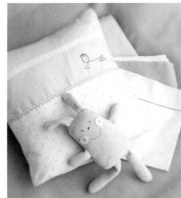

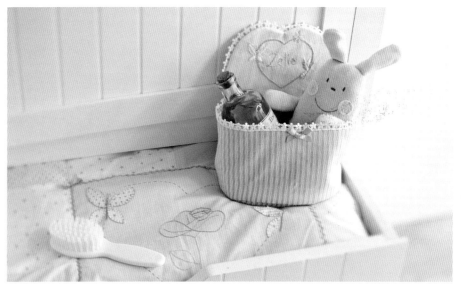

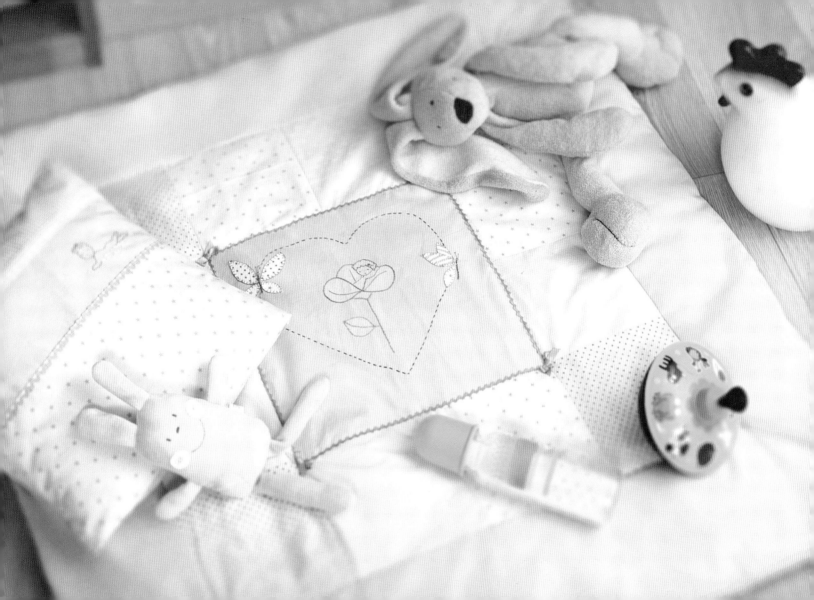

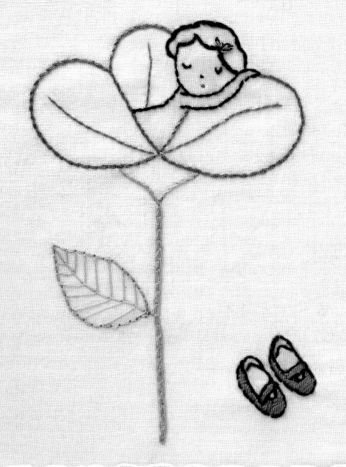
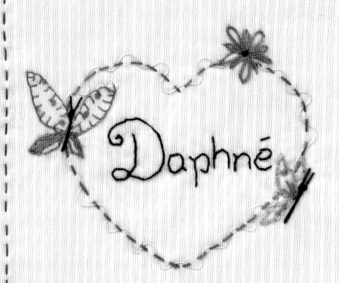

Daphné

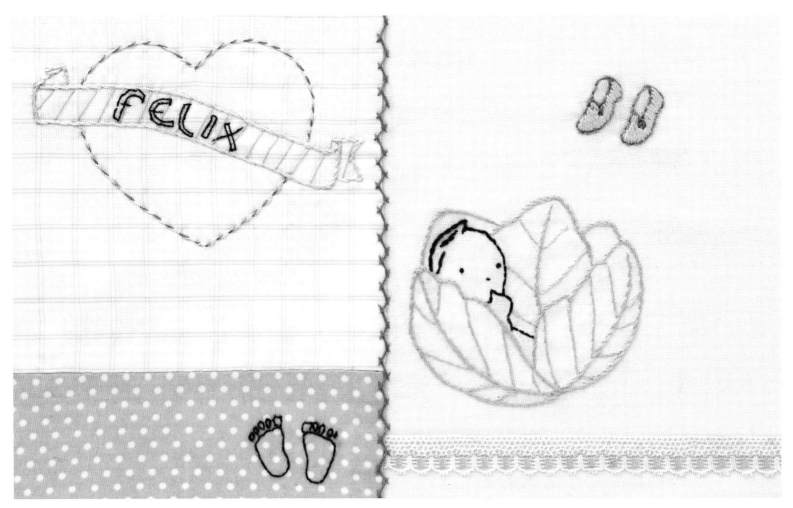

FELIX

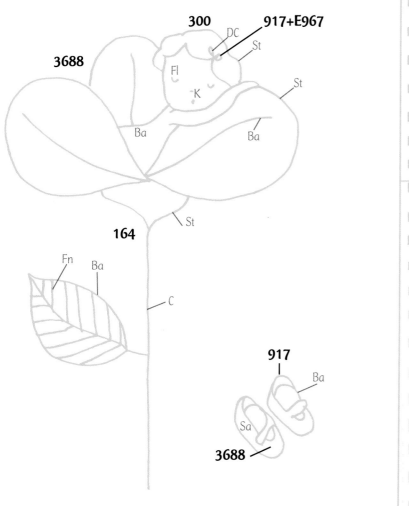

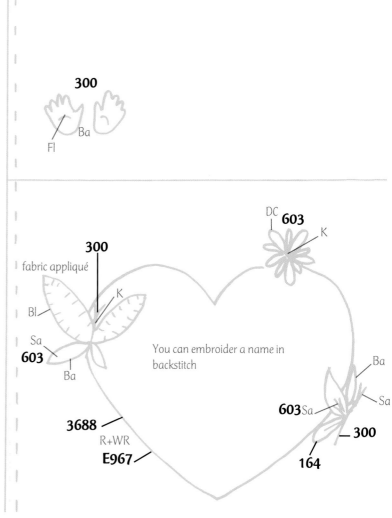

300

Fl Ba

DC 603

K

300

fabric appliqué

Bl

K

Sa

603

Ba

You can embroider a name in
backstitch

Ba

Sa

3688

R+WR

E967

603 Sa

300

164

3688

300

DC

Fl

917+E967

St

K

St

Ba

Ba

164

St

Fn

Ba

C

917

Ba

Sa

3688

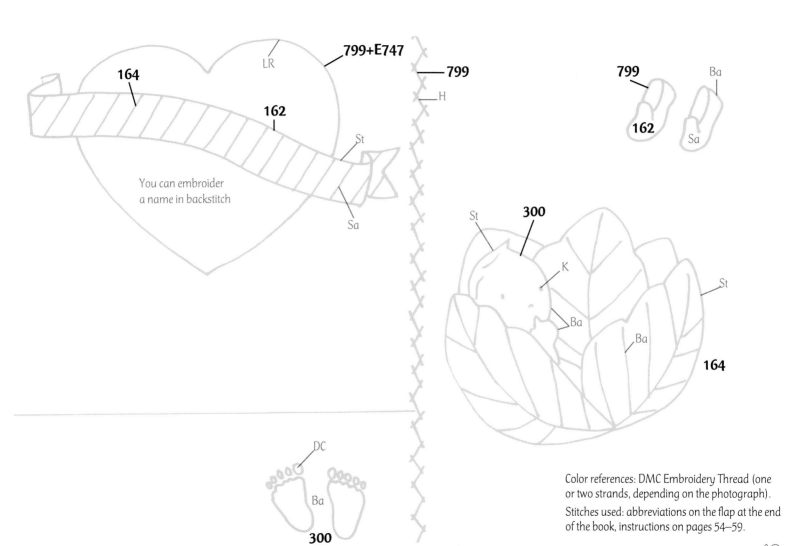

799+E747

164

LR

799

162

H

St

Sa

You can embroider
a name in backstitch

799

Ba

162

Sa

St 300

K

Ba

Ba

St

164

DC

Ba

300

Color references: DMC Embroidery Thread (one
or two strands, depending on the photograph).

Stitches used: abbreviations on the flap at the end
of the book, instructions on pages 54–59.

19

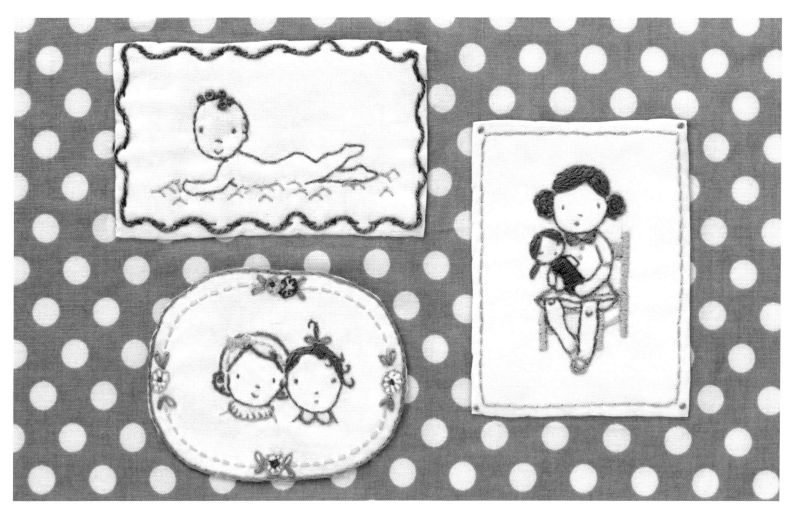

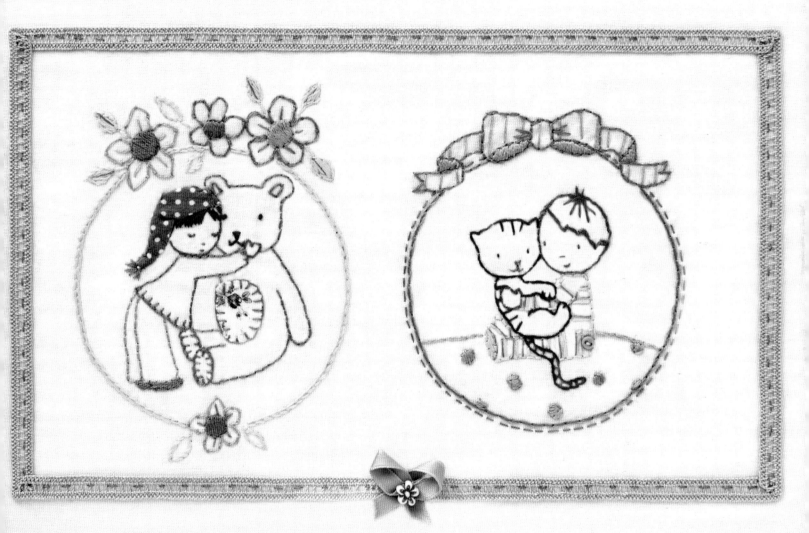

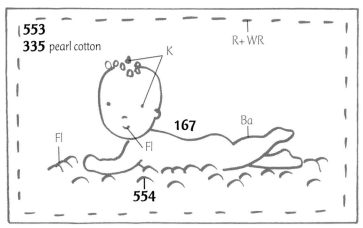

553
335 *pearl cotton*

R+ WR

K

167 Ba

Fl

Fl

554

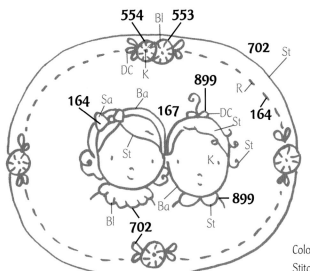

554 Bl **553**

DC K

702 St

899 R

DC

164 Sa Ba **167** St **164**

St

K St

899

Ba

Bl **702** St

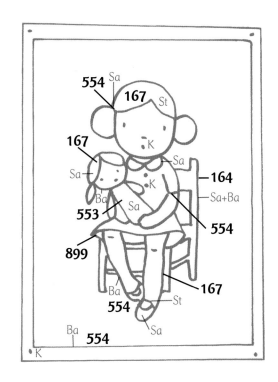

554 Sa

167 St

167 K

Sa Sa

164

Sa+Ba

553 Sa **554**

Ba

899

Ba

554 St **167**

Ba **554** Sa

K

Color references: DMC Embroidery Thread (one or two strands, depending on the photograph).
Stitches used: abbreviations on the flap at the end of the book, instructions on pages 54–59.

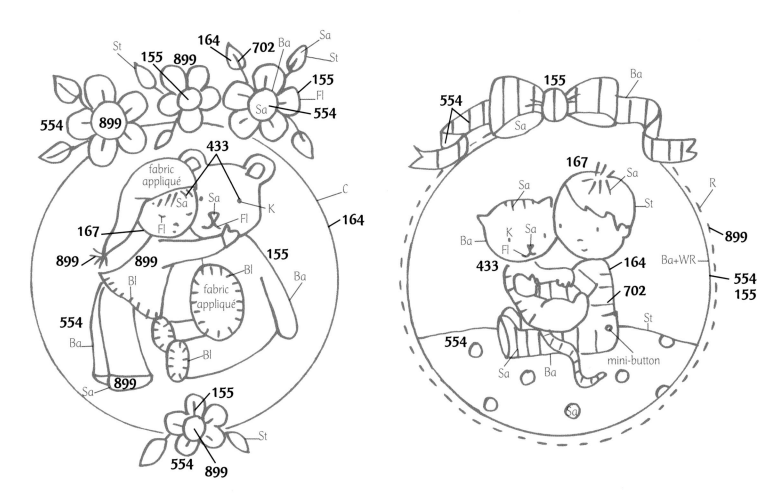

St
164
155 899
702 Ba
Sa
St
554 899
155
Fl
Sa 554
433
fabric appliqué
Sa
Sa
K
167
Fl
899 899
Bl
155
Bl
fabric appliqué
Ba
554
Ba
Bl
Sa 899
155
St
554 899

554
155
Ba
Sa
167
Sa
St
R
Sa
899
Ba
K Sa
Fl
Ba+WR
433
164
554
702
155
554
St
Sa
Ba
mini-button
Sa

23

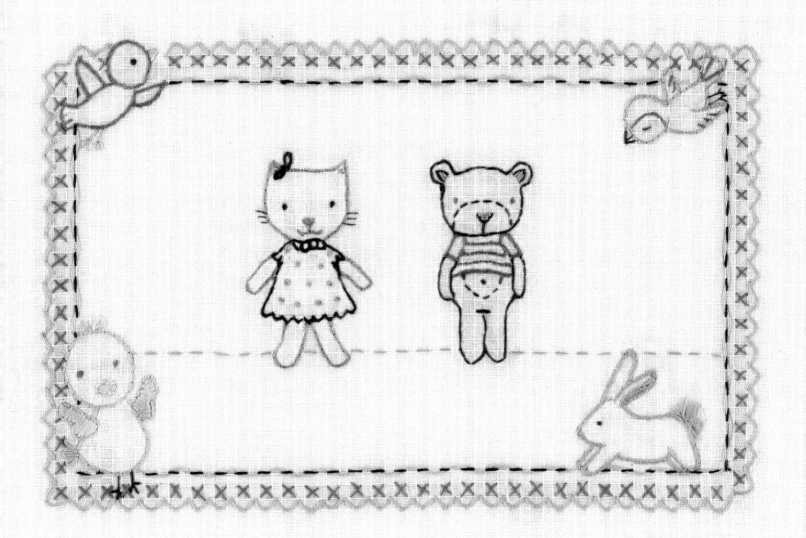

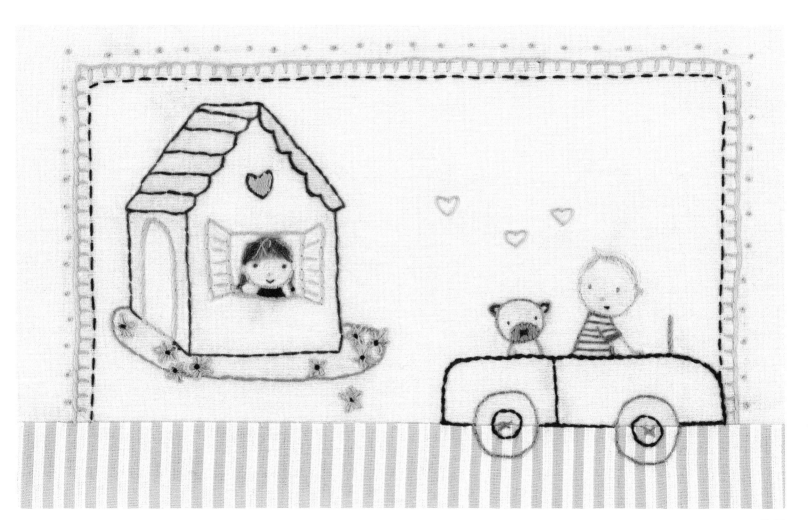

25

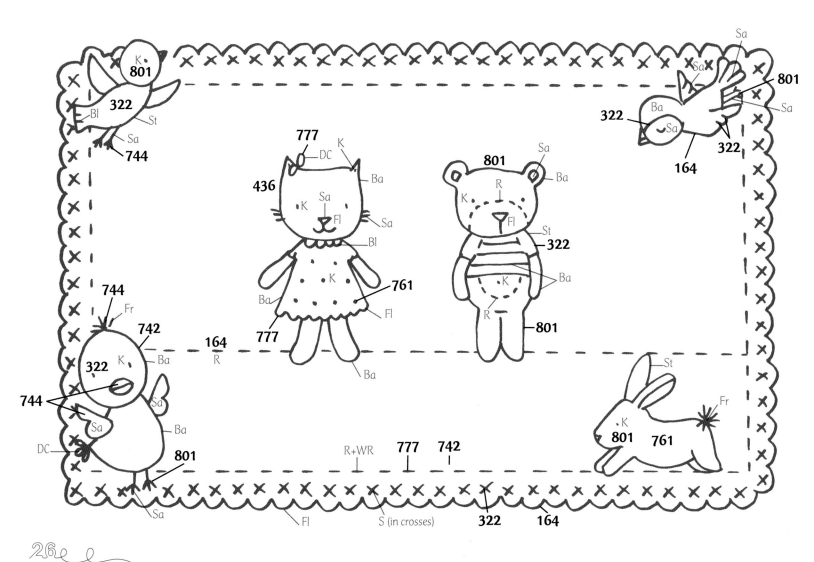

26

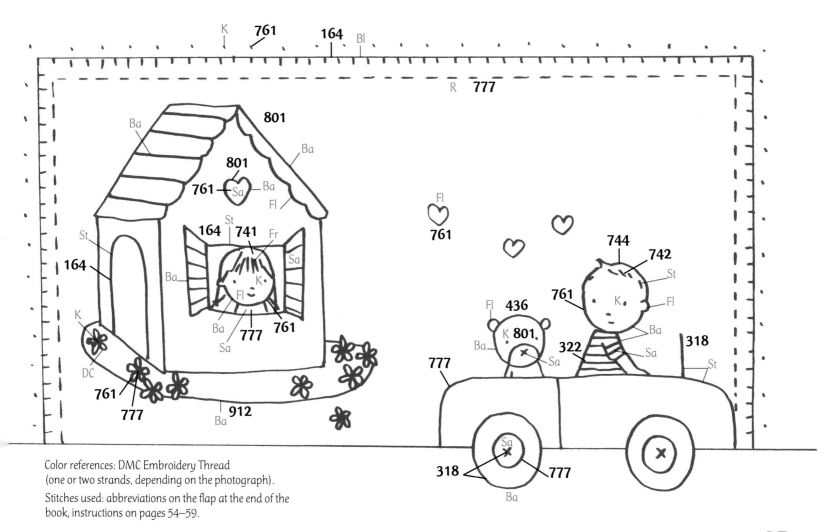

Color references: DMC Embroidery Thread
(one or two strands, depending on the photograph).

Stitches used: abbreviations on the flap at the end of the
book, instructions on pages 54–59.

27

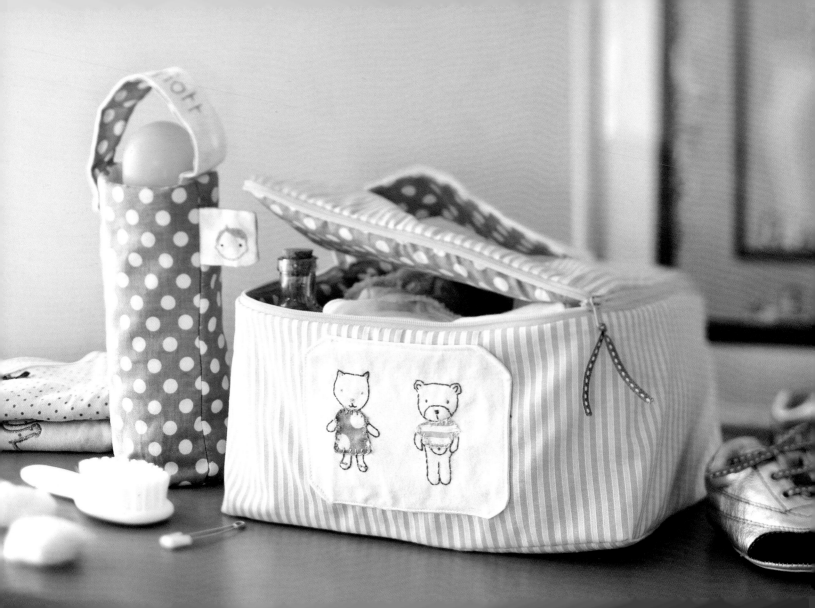

Travel case
designs page 26
instructions page 61

Bottle carrier
designs page 42
instructions page 61

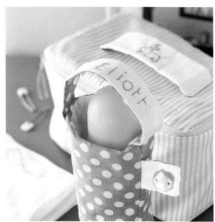

Chair pad
design page 9
instructions page 63

Organizer with top
design page 22
instructions page 60

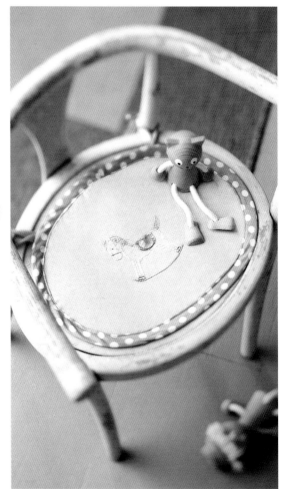

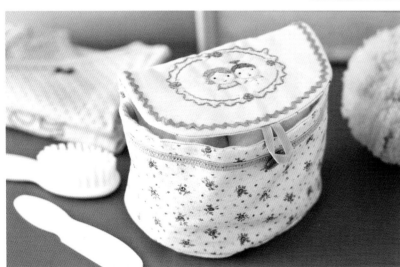

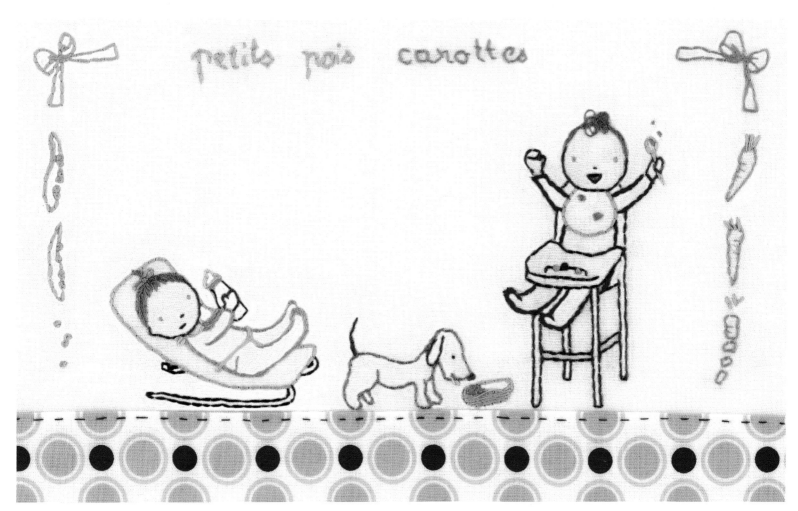

petits pois carottes

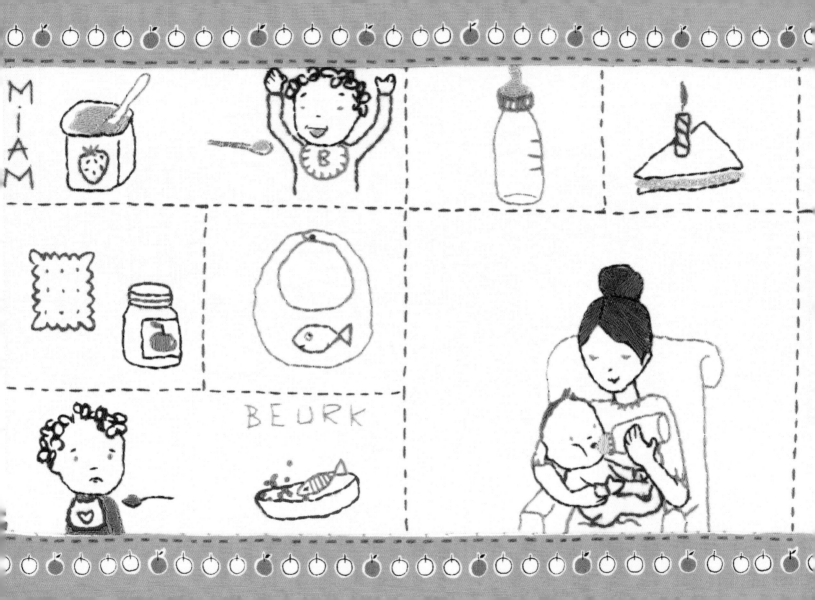

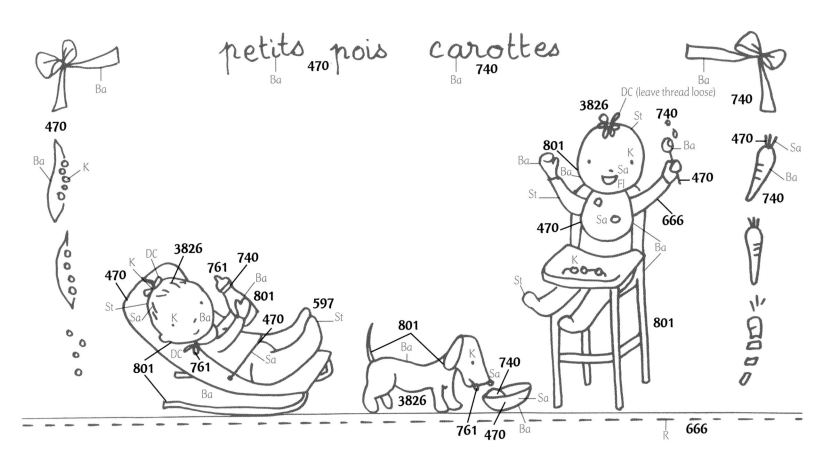

petits pois carottes

Color references: DMC Embroidery Thread (one or two strands, depending on the photograph).

Stitches used: abbreviations on the flap at the end of the book, instructions on pages 54–59.

MiAM

666 597 Sa Ba 761 470 Ba 801 Sa Ba 666

Sa DC Ba 801 Sa Fl B Bl Ba 597 761 Ba Sa 666 470

761 Ba 470 Sa Bl 597 Ba Sa

3826 DC Sa 666 Ba C 801 761

3826 Fl K 666 Ba St 470 Sa 801

666 K Ba 470 3826 597

801 OS Ba 3826 Sa Ba 597 Fl 597 Sa Ba Bl Ba 3826 761 470 St 801 Bl 666 Ba

DC 801 K St Sa 470 801 666 Sa Ba 597 Fl

597 Fl BEURK Sa

470 597 Sa K 666 Ba

33

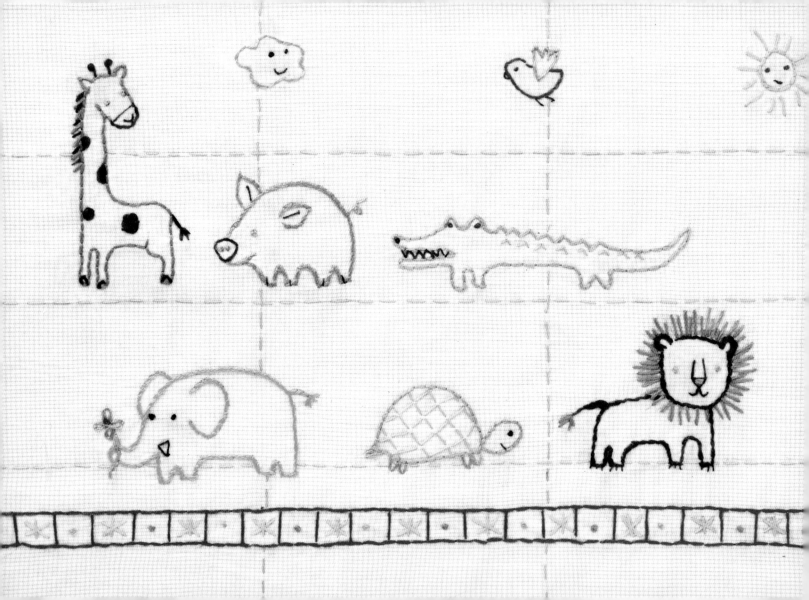

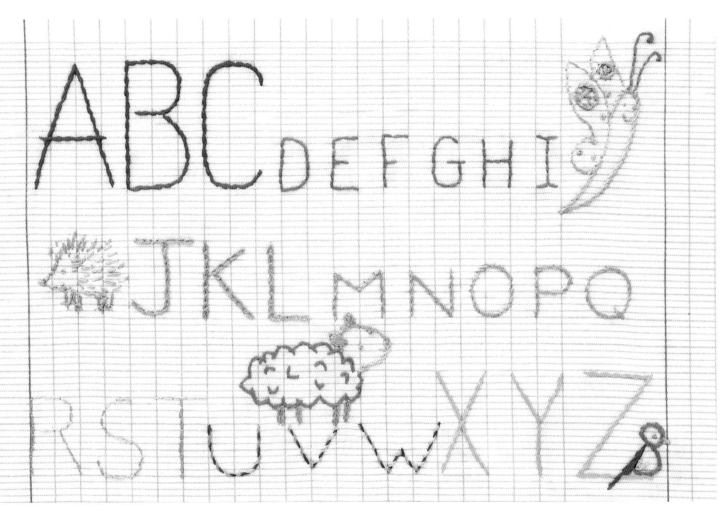

ABCDEFGHI
JKLMNOPQ
RSTUVWXYZ

35

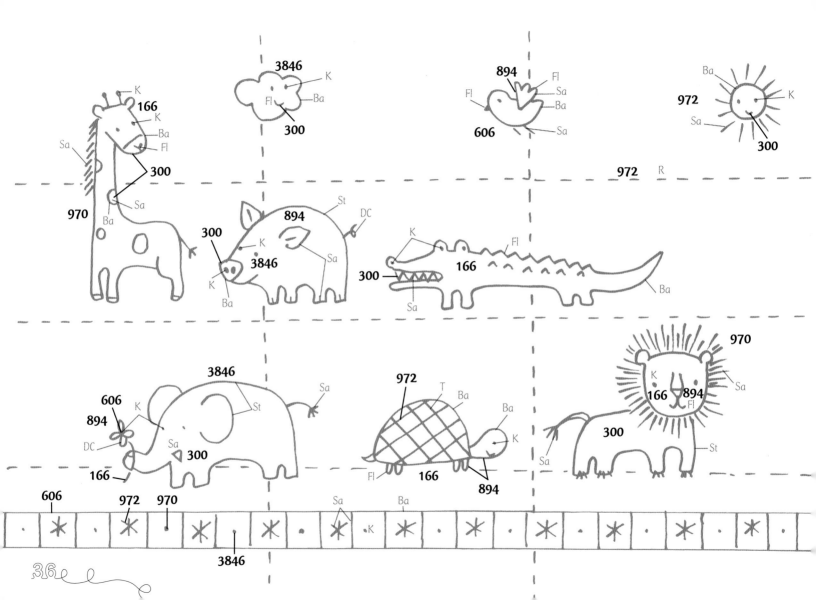

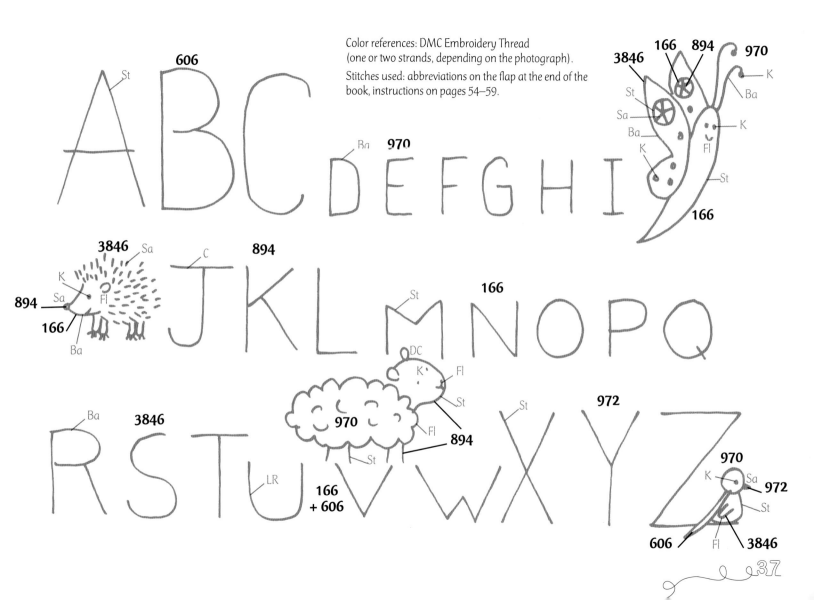

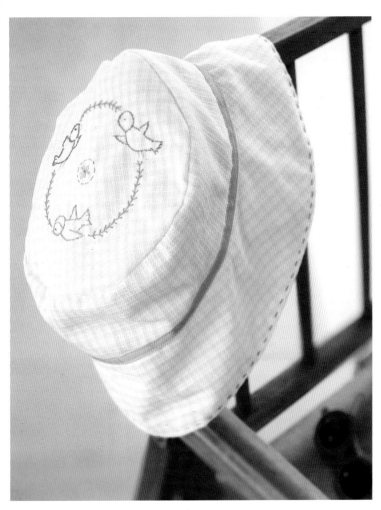

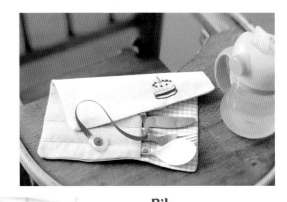

Hat
designs pages 26 and 27
(little flower)
instructions page 62

**Terrycloth towel
and wash glove**
designs page 32 and 33

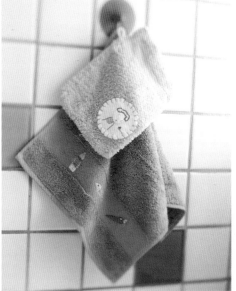

Bib
design page 33
instructions page 62

**Spoon, fork, and
knife kit**
design page 46
instructions page 60

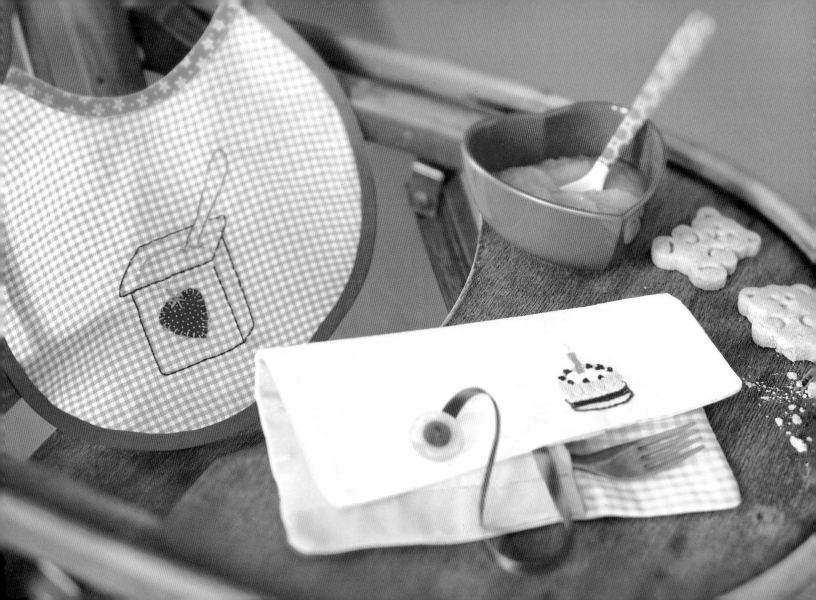

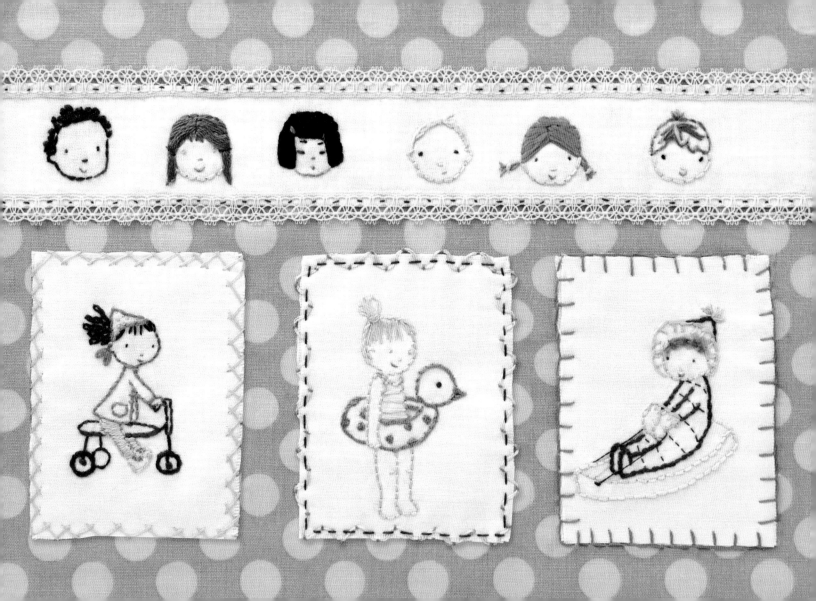

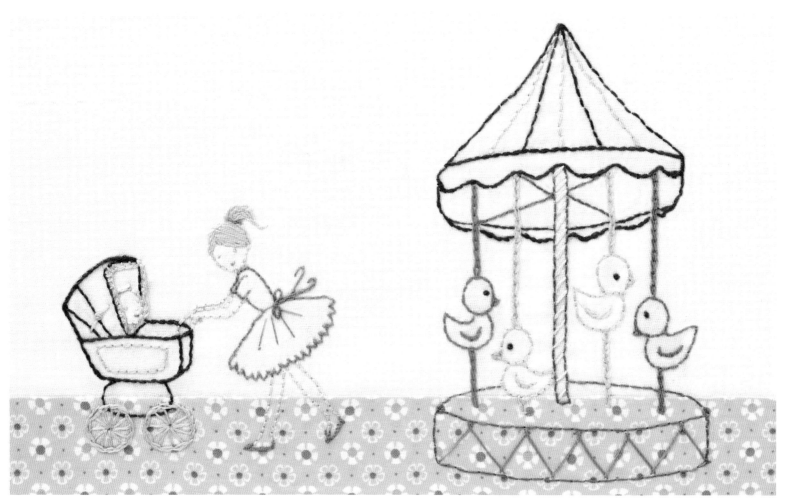

41

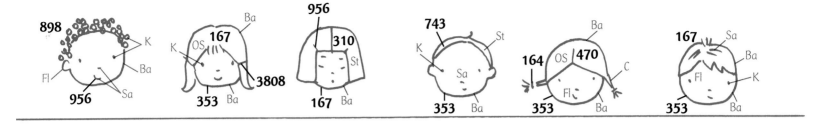

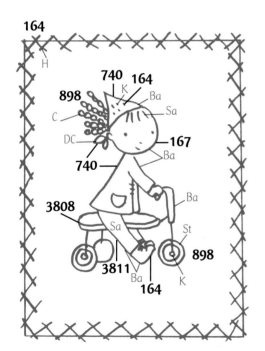

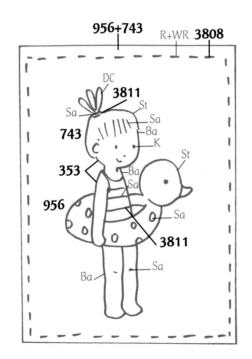

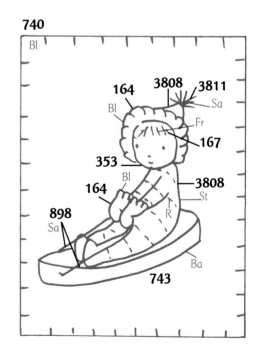

Color references: DMC Embroidery Thread (one or two strands, depending on the photograph).
Stitches used: abbreviations on the flap at the end of the book, instructions on pages 54–59.

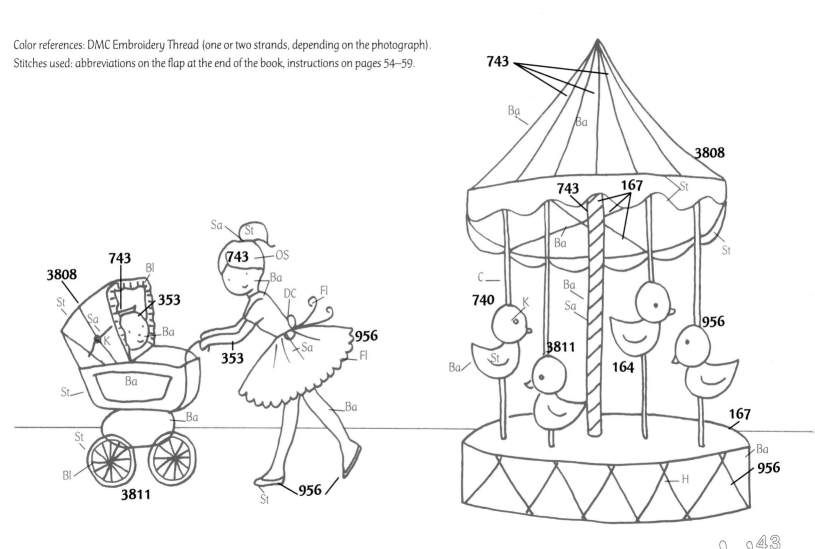

743

Ba

Ba

3808

St

743 167

Ba

St

C

740 K

Ba
Sa

Ba

St

3811

164

956

Ba

956

167

Ba

956

H

3808

743 Bl

St

Sa 353

K Ba

St

Ba

St

Bl

3811

Sa St

743 OS

Ba

DC Fl

353

Sa

956

Fl

Ba

956

St

43

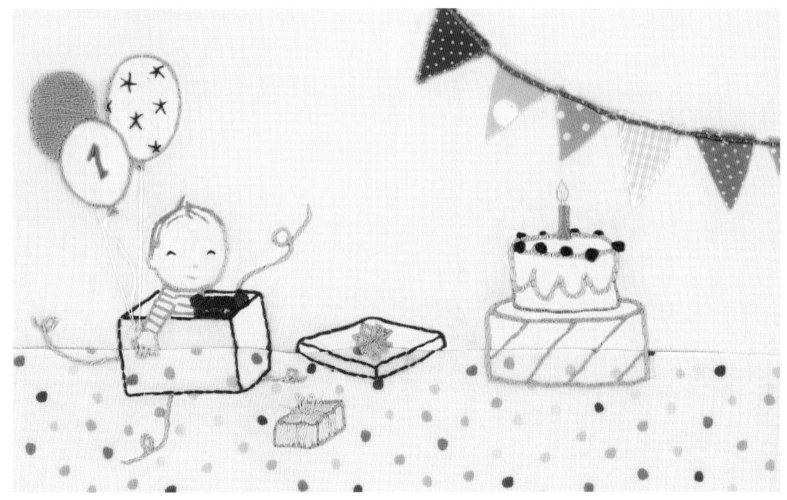

44

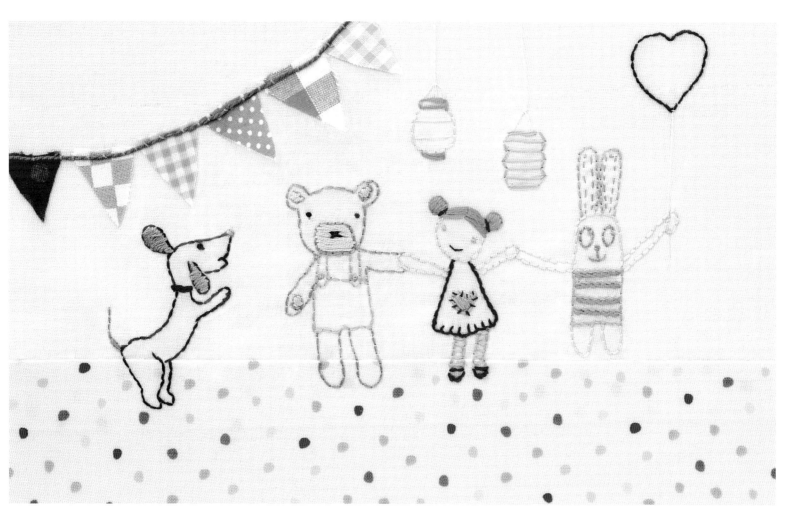

45

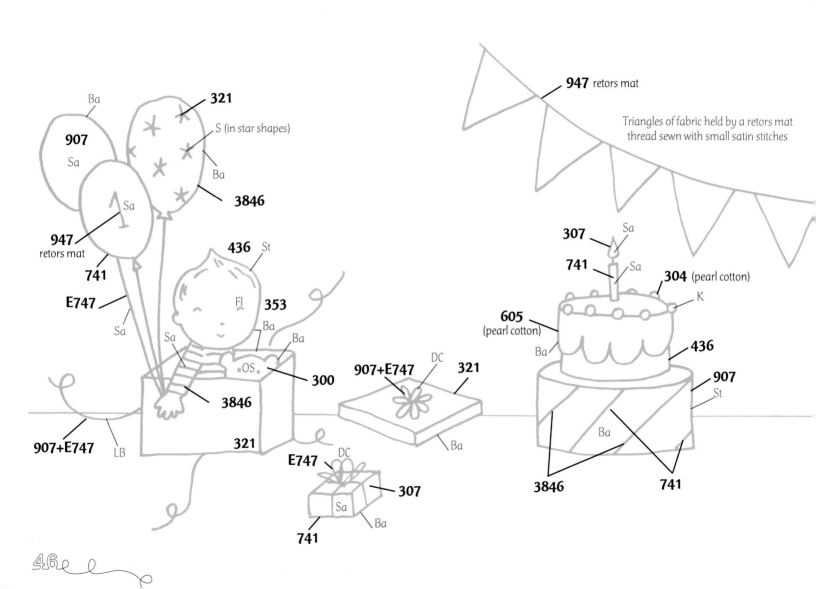

Ba
907
Sa
321
S (in star shapes)
Ba
3846
Sa
947
retors mat
741
E747
Sa
436 St
Fl
353
Ba
Ba
Sa
OS
300
3846
321
907+E747
LB
947 retors mat

Triangles of fabric held by a retors mat thread sewn with small satin stitches

E747 DC
741
Sa
Ba
307

907+E747 DC
321
Ba

307 Sa
741 Sa
304 (pearl cotton)
K
605 (pearl cotton)
Ba
436
907 St
Ba
3846
741

46

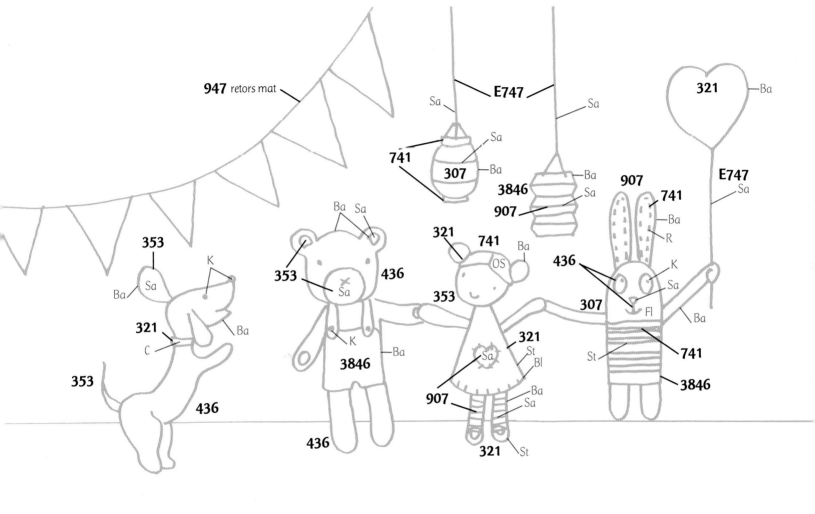

Color references: DMC Embroidery Thread (one or two strands, depending on the photograph).

Stitches used: abbreviations on the flap at the end of the book, instructions on pages 54–59.

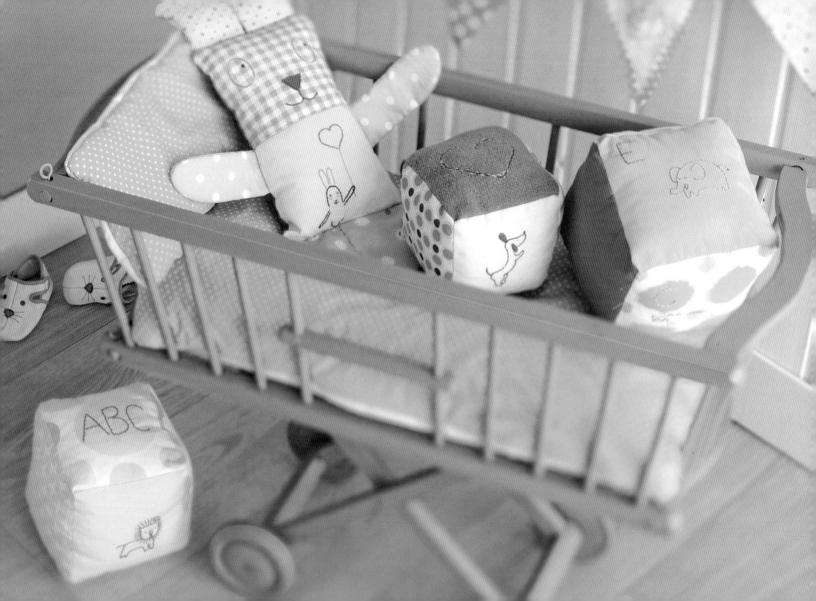

Blocks

designs pages 36, 37, and 47
instructions page 62

Pennant garland

designs pages 36, 46, and 47
instructions page 63

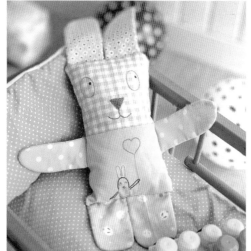

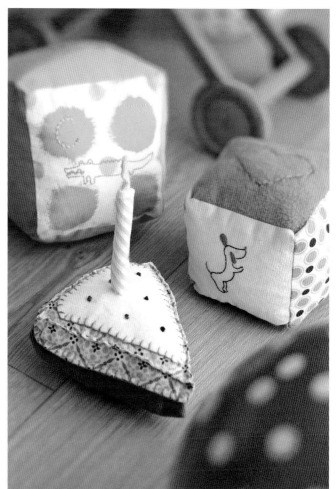

Cuddly rabbit

designs page 47
instructions page 63

Slice of cake

instructions page 63

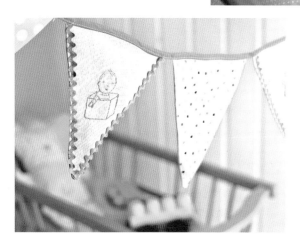

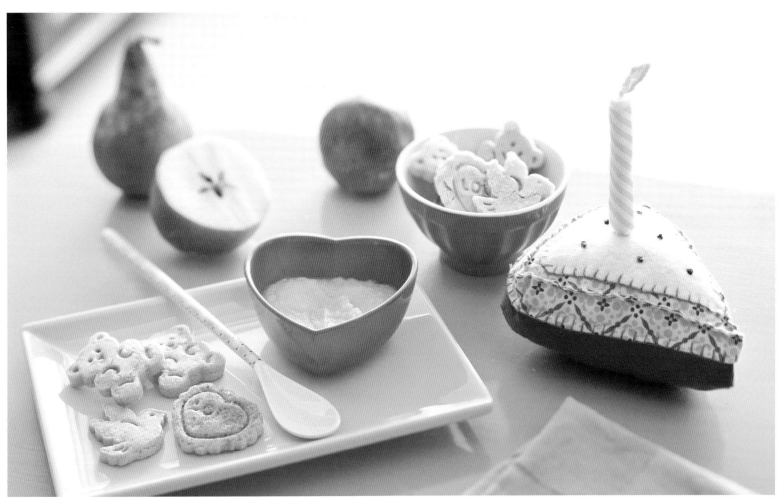

The embroiderer's recipe

Apple, peach, and pear compote with little shortbread cookies

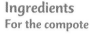

Ingredients

For the compote

- 3 golden apples
- 2 peaches (fresh or frozen)
- 1 small pear
- 4 tablespoons of honey
- 3 Tbs of butter
- 1 orange, squeezed
- 1 cup (25 cl) water

For the shortbread

- 1 cup (250 g) flour
- 1 tsp baking powder
- ½ cup (125 g) butter
- ¼ cup (70 g) powdered sugar
- 1 packet (2 tsp.) vanilla sugar
- 1 egg

Compote

Peel the fruit and dice into small pieces. Melt the butter in a saucepan and brown the apples for about 2 minutes. Add the diced peaches and pear, then the water. Cook over medium heat for about 15 minutes, stirring occasionally.

Add the orange juice and honey. Cook another 5 minutes.

Shortbread cookies

Combine the sifted flour with the baking powder in a bowl. Add the butter, cut up into little pieces, and work it in with your fingertips. Add the sugar, the vanilla sugar, and the egg. Knead well to obtain a smooth dough. Chill in the refrigerator if the dough gets too sticky.

Roll out the dough to a thickness of 2 inches (5 m). Cut into shapes with a cookie cutter. If you wish, you can brush the shortbread with a lightly beaten egg yolk.

Arrange on a baking sheet covered with parchment paper and bake in a medium oven, 300° F (150° C; setting 5) for 6 to 8 minutes.

Relax with your baby and enjoy!

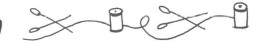

Supplies

The fabric
As a beginner, it's best to use a fairly tightly woven cotton fabric in a pastel color. If you sew, you can have fun mixing and matching fabrics. You can also begin with fabric objects such as pillows, aprons, and tea towels.

Mechanical pencil and eraser
A regular pencil works perfectly for drawing designs on light-colored fabrics.

Embroidery hoop
It's not essential, but tightly stretched fabric helps make your stitches more regular.

Embroidery needles
They have an elongated eye and nice sharp points. Number 9 needles are perfect.

Embroidery scissors
Their short blades cut threads very close to the fabric surface, so there's no risk of losing control!

DMC Embroidery Threads
are available in more than 450 colors. The range includes metallic threads (Light Effects) and shaded threads (Color Variations). The floss consists of six easily separated strands. The embroidery designs in this book generally use one or two strands depending on the desired thickness.

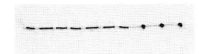

1 strand

2 strands

3 strands

4 strands

Start out right!

Transfer the design
Photocopy the design you have chosen in the desired size, or trace it.

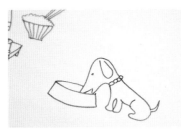

Using tracing paper, trace the design with a pencil onto carefully ironed fabric. You can tape the design and the fabric to a window to increase transparency.

For dark-colored fabrics, you can buy special embroidery transfer pencils or carbon paper at a notions shop.

Stretch the fabric (if you want to . . .)
Place the fabric between the two rings of the embroidery hoop with the screw loosened.

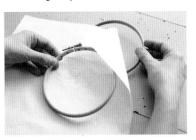

Place the rings together and tighten the screw, pulling the fabric around the hoop if necessary.

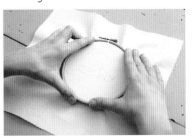

Thread the needle
Pull on the end of the skein.

Cut off a piece 12 to 16 inches
(30 to 40 cm) long.

Separate as many strands as you need.

Slide the thread through the eye. It's easier if
you moisten it.

Start embroidering
Without making a knot in the thread, bring
the needle up through the outline of the
design, and then pull it through, leaving

about ½ inch (1 or 2 cm) of thread hanging
down underneath. Continue embroidering,
securing the end of the thread beneath your
next few stitches.

Finishing off
To end a piece of thread, run it beneath
the last few stitches. Snip off the end of the
thread so it is flush with the fabric.

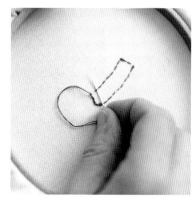

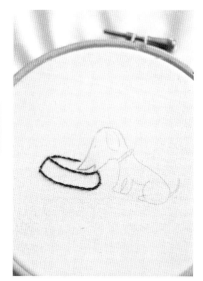

Follow that thread!

Now you know the basics. Practice with a simple outline stitch (the
following pages will help you). Gradually begin experimenting with
other stitches. Play with the scale of the designs, or add ribbons, beads,
buttons, and even fabric appliqués: just fold under the raw edge of the
fabric all around, then sew it on with tiny stitches.

A collection of stitches

Use the simplest outline stitches in pretty colors, and you'll start making beautiful things right away! The selection below will help you try out new effects and have even more fun. The stitches used in the models are indicated by abbreviations next to them. The alphabetical list of these abbreviations printed on the flap at the back of the book will be a useful reference.

Outline stitches

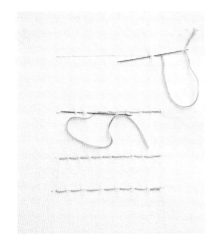

Running stitch (R)

Working from right to left, pass the needle through the fabric in an up-and-down motion at regular intervals. For an almost continuous line, leave only one or two threads in the fabric weave between each stitch. For a looser look, space the stitches farther apart.

Helpful hint

The direction given for these stitches is for a right-handed person. If you're left-handed, look at the diagrams in a mirror.

Backstitch (Ba)

Worked from right to left, as its name suggests, this stitch embroiders from front to back. Make short, regular stitches, as close together as possible.

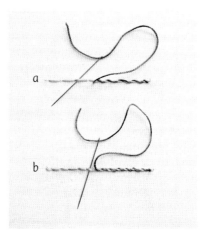

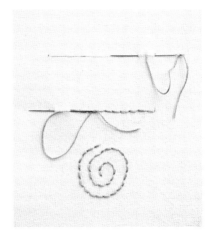

Laced running stitch (LR) or Laced backstitch (LB)

Embroider a line in running stitch (a) or backstitch (b). Lace another thread from top to bottom over each stitch you've already made.

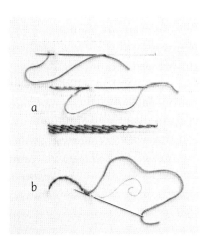

Stem stitch (St)

Work from left to right, and bring the needle up halfway back behind each stitch while keeping the loop of thread below the needle. Arranged in side-by-side lines, this stitch can be used to fill in forms (a). To follow curved lines perfectly, combine the "backward" variation of the stem stitch with the traditional version of the stem stitch. Proceed in the same fashion, but keeping the thread above the needle (b).

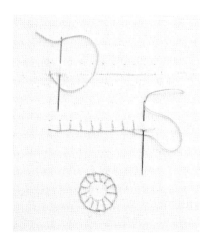

Blanket stitch (Bl)

This stitch can be used for straight lines, curves, or circles (wheels), working from left to right. Insert the needle into the fabric above the line and bring it through on the line, keeping the thread to the right. Space the stitches regularly.

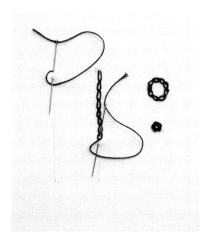

Chain stitch (C)

This stitch can be used to outline or fill in. Work from top to bottom. Make regular loops by passing the thread under the needle with each stitch. Finish the last loop with a small straight stitch.

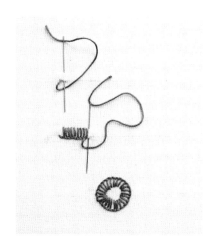

Buttonhole stitch (Bu)

This stitch is done like the blanket stitch but with the stitches more closely spaced.

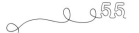

Detached stitches

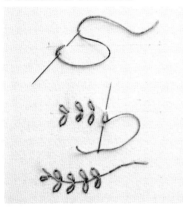

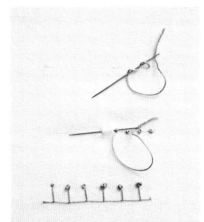

Detached chain stitch (DC)
Do this stitch like a chain stitch, securing each loop individually with a straight stitch, using the length appropriate for the desired effect.

Knot stitch (K)
Bring the needle up through the fabric. With your left hand roll the thread one, two, or three times in tight loops around the needle. While still holding the thread, insert the needle back down into the fabric in the same spot where you brought the needle up. Pull the thread, sliding the loops off. The knot is now formed.

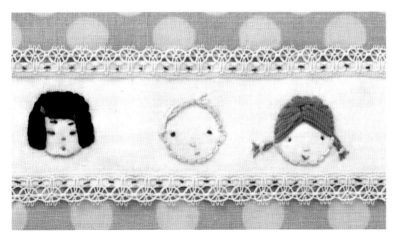

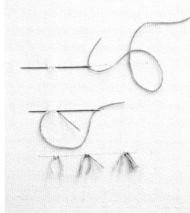

Fringe (Fr)
This stitch is used for animal whiskers, the ends of pigtails, etc. Leave the thread on the front of the fabric, and make two little stitches one on top of the other. Then cut, leaving the end of the thread loose. Repeat as necessary.

Filling stitches

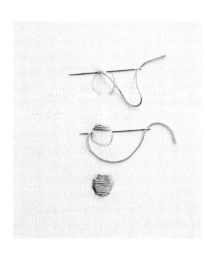

Satin stitch (Sa)
This stitch is most frequently used to fill In small areas. Bring the needle up at the edge of the area to be covered and bring the thread all the way across it, inserting the needle back down on the opposite edge of the design. On the reverse side, bring the needle back up right next to where you began the preceding stitch. Align the stitches to create the desired effect. You can also space them further apart or use them individually.

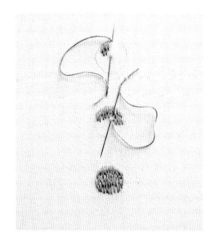

Long and short stitch (LS)
Embroider a row of vertical satin stitches, alternating short and long stitches. Then, working in the opposite direction, make satin stitches of the same length under the short stitches. Continue over the entire area of the design. This stitch is ideal for covering larger surfaces and allows you to create lovely color shading effects.

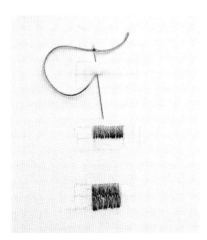

Overlapping satin stitch (OS)
Embroider a row of vertical satin stitches. For the second and additional rows, bring the needle up between two stitches of the preceding row; the rows will overlap each other.

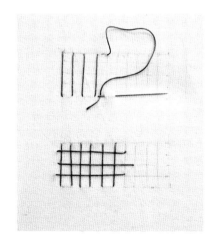

Trellis (T)
Embroider a series of regularly spaced stitches, and then another set perpendicular to the first, interweaving each stitch with those in the first series before inserting the needle back into the fabric.

Borders and edgings

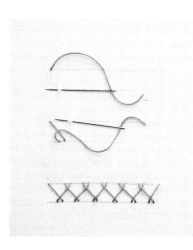

Herringbone stitch (H)
This stitch is executed in two parallel lines. Bring the needle to the upper line. Take a small straight stitch from right to left, inserting the needle back down at the lower line. Take another small straight stitch on the lower line. Then make another small straight stitch on the upper line. Space the stitches evenly.

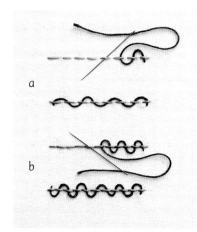

a

b

Whipped running stitch (WR)
Embroider a line of running stitches (a) or backstitches (b). Lace a second thread up and down through the stitches already made, creating the effect of a wave.

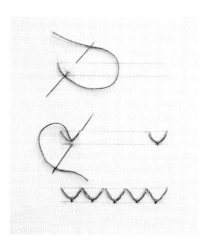

Fly stitch (Fl)
This stitch is done from left to right, in lines, overlapping lines, or individually. Bring the needle up to the left of the line and insert it into the fabric as if making a straight stitch, forming a V-shaped loop without pulling too hard on the thread. Bring the needle up again farther down, in the middle of the stitch, and make a vertical straight stitch to secure the previous stitch.

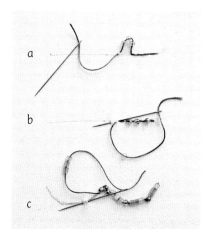

a

b

c

Beading (Be)
Depending on your design, there are a number of ways to attach the beads:
- running stitch (a)
- backstitch (b)
- combination of running stitch and backstitch (c)

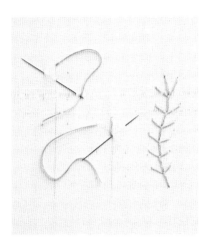

Fern stitch (Fn)

Begin at the top of the line. Make three running stitches of the same length, forming an angle between them and inserting the needle through the same hole at the base of each of the three stitches. To continue the design, make the next stitch just below the first and continue in the same way.

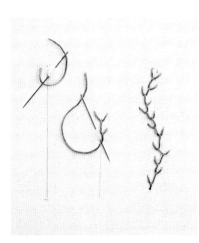

Feather stitch (Fe)

Bring the needle up at the top of the line, then alternate to the left and right, always keeping the needle above the length of thread.

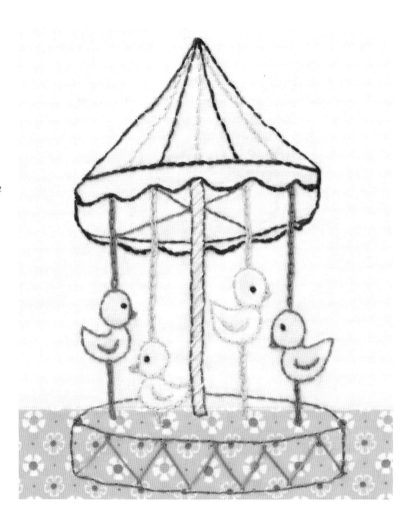

Embroidering is terrific fun, and showcasing your creations on decorative and useful objects is doubly satisfying. The projects in this book are designed for both new and experienced embroiderers, and they can also be a source of inspiration for you. Feel free to embroider any design you like on something store-bought or hand-made. Customize the colors, fine-tune the dimensions—personalize however you please!

To keep the instructions simple, only the specific supplies and the sewing steps needed for each project are given. Seam allowances are included. For the embroidery designs, refer to the photographs and design pages. For a professional quality finish, match the thread colors, oversew the pieces of fabric, and flatten the seams with an iron as you go along.

Keep it organized!

Organizers (two versions)

Supplies

Two or three fabrics (one solid linen for embroidering), flannel, lace, ribbon, button for the closed version.

1 Referring to the designs on page 64, cut two strips measuring 4¾ x 17¾ inches (12 x 45 cm) for the interior and exterior of the organizers and four 7 x 17¾ inch (18 x 12 cm) rectangles. Arrange the fabrics and the linen to be used for the embroidery according to the design selected. Round off two corners of each rectangle. For the open version, you can cut two of the rectangles into a heart shape. Also cut a strip and two rectangles from the flannel. Embroider the design, following the model.

2 For the exterior of the organizers, with right sides facing in, sew the flap and the bottom on either side of the strip, keeping them ¼ inch (0.5 cm) from the left edge.

3 Lay the bottom, the top flap, and the strip of remaining fabric on top of the pieces of flannel. Sew the pieces: right sides facing in as before, stitching through the four layers, and leaving an opening in the middle of the bottom seam.

4 Sew the strip around the curve of the bottom, then sew the shorter sides of the strip. Do the same for the lining of the organizers. Place the two parts of the organizers together, one inside the other, right sides facing in. For the closed version, attach a ribbon loop to the center of the top flap. Stitch ¼ inch (0.5 cm) all around. Turn the organizer right side out through the opening in the bottom, then close the opening with little stitches.

5 Finishing: depending on the version selected, hand stitch decorative lace or ribbon. Sew on a button under the button loop. For the open version, you can also add a couple of loops on the back to attach it to something—a crib slat, for example.

Spoon, fork, and knife kit

Supplies

Three different fabrics (one should be unbleached linen for embroidering), ribbon, button.
Seam allowance: ¼ inch (0.5 cm).

1 Cut an 8 x 8 inch (20 x 20 cm) square from the linen, on which you will embroider an 8 x 4¾ inch (20 x 12 cm) rectangle. Cut two pieces of the same dimensions from the other fabrics.

2 Sew the two rectangles together, right sides facing in, stitching one of the long sides. Turn right side out and place this "pocket" on the square of patterned fabric, lining side out, aligning the open sides to the edges of the square. Sew down vertically, first 3½ inches (9 cm) from the left edge, then 3 more times every 1¼ inch (3 cm).

3 Lay the ribbon on the embroidered side of the linen square, and lay the square with the pocket on top, right sides facing in. Sew all around, leaving an opening. Turn right side out. Close the opening with little stitches. Stitch a button onto the ribbon. You can wrap this around the case to fasten it.

Bottle carrier

Supplies

Two fabrics (one should be solid linen for embroidering), felt, button.
Seam allowance: ¼ inch (0.5 cm).

1 From each fabric, cut a 9 x 8 inch (23 x 20 cm) rectangle for the body, a circle 3 inches (8 cm) in diameter for the bottom, and an 8½ x 1½ inch (22 x 4 cm) strip for the handle. In the same way, cut out a rectangle and a circle from the flannel. For the label, cut out a 2 x 1½ inch (5 x 4 cm) rectangle from both fabrics. Embroider the design. Sew the two pieces on three sides, right sides in. Then turn right side out.

2 Make a gather of about 1 inch (3 cm) around the base and sew it right side facing in to one of the long sides of the rectangle. Sew up the body of the carrier right side in, inserting the label into the interior ¾ inch (2 cm) from the top.

3 Lay the lining of the body and the base on the corresponding pieces of flannel and sew together as above, leaving a 2 inch (5 cm) opening in the seam of the body.

4 Embroider the handle. Lay the lining for the printed fabric on top, right side facing in. Sew on three sides, then turn right side out through the open end.

5 Align the end of the handle with the top of the body's exterior fabric, facing the seam. Slide the carrier into its lining, right side facing in. Sew around. Turn right side out through the opening and close the opening with little stitches. Attach the other end of the handle to the body with a button.

Travel case

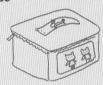

Supplies

Three different fabrics (one solid), flannel, 21½ inch (55 cm) zipper.
Seam allowance: ¼ inch (0.5 cm).

1 Cut two 10 ¼ x 6¾ inch (26 x 17 cm) rectangles and a 33½ x 5½ inch (85 x 14 cm) strip in each of the two printed fabrics, as well as in the flannel. For the handle, cut 3 strips, each measuring 6¼ x 2 inches (16 x 5 cm): one from the solid fabric (on which you will embroider the design), another from the lining fabric, and the last from the flannel.

2 Make the handle: place the embroidered fabric on its lining, right sides facing in, and the lining on the flannel. Stitch the four sides, leaving an opening in the middle of a long side. Turn right side out, then close the opening with small stitches. Center the handle on the outside of the top of the case and stitch down the two shorter sides.

3 For the appliqué, cut out two rectangles measuring 5 x 4 inches (13 x 10 cm) from the solid fabric. Embroider the designs on one of them. Sew the rectangles right sides in, leaving an opening, and sew the corners on the bias. Snip off surplus fabric. Turn right side out.

4 With right sides facing in, sew one side of the zipper along three sides of the top. Sew the second side of the zipper to one of the long sides of the strip, leaving ¼ inch (0.5 cm) of extra fabric. Sew the fourth side of the top to the end of the zipper. Sew on the appliqué panel, centering it on the front. Sew the bottom of the strip to the base and close up the short sides.

5 Lay the lining pieces on top of the pieces of flannel. Sew the top and the bottom on either side of the strip, leaving ¼ inch (0.5 cm) to the left, then sew the strip to the three other sides of the bottom, leaving an opening. Finally, sew the short sides of the strip.

6 Insert the case in its lining, right sides facing in. Begin stitching the three sides of the top, attaching the zipper between the layers, then sew along the strip. Turn right side out. Close the opening with little stitches.

Feeling right at home

Pillow

Supplies

Three different fabrics (one a solid color), rickrack, lace, 11¾ x 11¾ inch (30 x 30 cm) pillow.
Seam allowance: ¼ inch (0.5 cm).

1 Cut out three rectangles: one measuring 3¼ x 12½ inches (8 x 32 cm) from one of the fabrics, one measuring 4 x 12½ inches (10 x 32 cm) from the solid fabric (which you will embroider), and a third measuring 8¼ x 12½ inches (21 x 32 cm).

2 Sew the strips in order, right sides facing in. Stitch a piece of lace and rickrack over the seams. Hem the base, folding the fabric ¼ inch (0.5 cm) under two times, then fold 2 inches (5 cm) right side in.

3 Cut out a 12½ inch (32 cm) square for the back. Hem the sides, folding the fabric ¼ inch (0.5 cm) under two times. Lay it on top of the pillow cover's front side, right sides facing in, and stitch the three other sides. Turn right side out and insert the pillow in its cover.

Coverlet

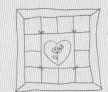

Supplies

Three different fabrics (in small squares), a solid fabric (for the back and borders), flannel, ribbon, 48 inches (120 cm) of rickrack.
Seam allowance: ¼ inch (0.5 cm).

1 Cut out twelve 6 inch (15 cm) squares (four squares from each of the three different fabrics). Then from the solid fabric cut an 11½ inch (29 cm) square (which you will embroider), four strips measuring 6 x 33½ inches (15 x 85 cm) for the borders, and a 33½ inch (85 cm) square for the back. Also cut out a 33 inch (84 cm) square from the flannel for the back.

2 Sew two small squares together two times, then sew them right side in to the left and right of the large embroidered square.

3 Sew two strips of four little squares, then sew these to either side of the parts already sewn. Stitch the rickrack around the large square.

4 With the right sides facing in, sew the strips around the patchwork, centering them, and let them extend over either side.

5 At each corner, fold one strip over the other to mark the diagonal. Lay the two strips on top of each other, right sides facing in, and stitch them all the way to the corner.

6 Lay the patchwork and the back together right sides in and stitch the four sides, leaving a 13¾ inch (35 cm) opening at the bottom. Turn right side out and slide the felt inside, closing the opening with small stitches. At each corner of the large embroidered square, stitch four bows of ribbon through all the layers of fabric so that the felt remains firmly in place.

Bib

Supplies

Fabric (plus a scrap of decorative fabric if you want to do an appliqué), bias binding in two different colors.

1 Referring to the sketch on page 64, cut out a circle of fabric with a diameter of 9½ inches (24 cm), then cut out the neckline. Embroider the design.

2 Place the first binding over the edge of the neckline and stitch. Stitch the second binding all around, leaving it extending about 9¾ inches (25 cm) on either end.

Hat

Supplies

Two different fabrics, ribbon.
Seam allowance: ¼ inch (0.5 cm) (included in the pattern).

1 Referring to the sketch on page 64, make a pattern. Tape the pieces together to test the pattern. Adjust as necessary.

2 Lay the pattern pieces out on the two fabrics. Embroider the design. To make the exterior, sew the first strip right side facing in around the circle of fabric, then sew on the second strip. Sew the shorter sides of the strips right side facing in.

3 Sew a ribbon all around the hat over the seam between the two strips.

4 In the same way, sew the lining fabric, leaving a 2 inch (5 cm) opening around the circle. Arrange the hat and its lining right side facing in and stitch the base. Turn it right side out through the opening and close the opening with small stitches.

5 Embroider a border using the running stitch all along the rim.

Toys and decorations for the bedroom

Blocks

Supplies

Three different fabrics per block, stuffing.
Seam allowance: ¼ inch (0.5 cm).

1 For each block, cut two 5¼ inch (13.5 cm) squares from each of the three fabrics for the large size; for the small model, use 4 inch (10 cm) squares. Embroider designs on two squares.

2 Sew the squares right side facing in to make a vertical strip of four squares, then sew one square to the right and another to the left of the second square.

3 Form the block by sewing the other sides, leaving an opening on one side to turn it right side out. Fill with stuffing.

Cuddly rabbit

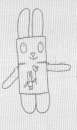

Supplies
Six different fabrics, stuffing, and flannel. Seam allowance: ¼ inch (0.5 cm).

1 Referring to the sketch on page 64, cut out all the pieces from the appropriate fabrics.

2 Embroider the design on the fabric to be used for the stomach, and embroider the face on the fabric for the head. Sew the two pieces right sides facing in.

3 To sew the arms, legs, and ears, arrange one of the pieces of fabric on the flannel, and then place the second piece of fabric on top, right sides facing in. Stitch, leaving the small straight side open. Turn right side out and iron.

4 Pin the arms, legs, and ears to the front of the rabbit; attach them inside the body, lining up the open edges to the edges of the body. Lay the back on top, right side facing in, and stitch all around, leaving an opening at the bottom. Turn right side out, fill with stuffing, and close up the opening with little stitches.

Pennant garland

Supplies
Printed fabrics, light-colored fabric to embroider, fabric for the backing, bias binding, rickrack.
Seam allowance: ¼ inch (0.5 cm).

1 For each pennant, cut out two isosceles triangles 7 inches (18 cm) high and 6 inches (15 cm) wide. Embroider the designs on the appropriate triangles.

2 Sew together all the fronts and backs, right sides facing in, leaving a small side open. Turn right side out. Stitch a length of rickrack on the longer sides of the fronts of the embroidered pennants.

3 Place a pennant within the open bias binding 19¾ inches (50 cm) from one end, and then space the remaining pennants regularly about ½ inch (1 cm) apart. Fold over the binding and stitch down its entire length.

Slice of cake

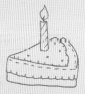

Supplies
Three different fabrics (two printed and one solid), felt, stuffing.

1 From two of the fabrics, cut out an isosceles triangle 6½ inches (16.5 cm) high and 6¾ inches (17 cm) wide. Round off the smallest side. Also cut out two strips measuring 17¾ x 1¼ inches (45 x 3 cm).

2 For the icing, cut out a rounded triangle slightly smaller than the first ones.

3 Arrange the icing on the top of the cake. Sew a border all around with three strands of thread. Embroider knot stitches in rows on top.

4 Pin each strip around the triangle of the same color, right sides facing in, gathering at the corners. Stitch. Close up the end of each strip. Sew the two strips right sides facing in, leaving an opening in the back. Turn right side out and insert stuffing. Close opening with small stitches.

5 Sewing through two thicknesses of fabric with each stitch, embroider around the top of the cake using the running stitch; where the two strips are joined, use the blanket stitch.

6 For the candle, cut out a 1½ x 3½ inch (4 x 9 cm) rectangle from the third fabric, and stitch the long side. Turn right side out and stuff with a role of felt. Close the base and sew on a flame cut from the felt. Stitch it to the center of the top of the cake.

Chair pad

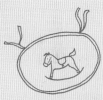

Supplies
Fabric to embroider, binding (or fabric to make a binding), ribbon.

1 Cut out a shape, fitted to the chair, two times. Embroider one of the pieces of fabric.

2 Lay the pieces of fabric together, back to back. Pin the binding over the edges of the pad and stitch. Sew two ribbons to the back of the chair pad.

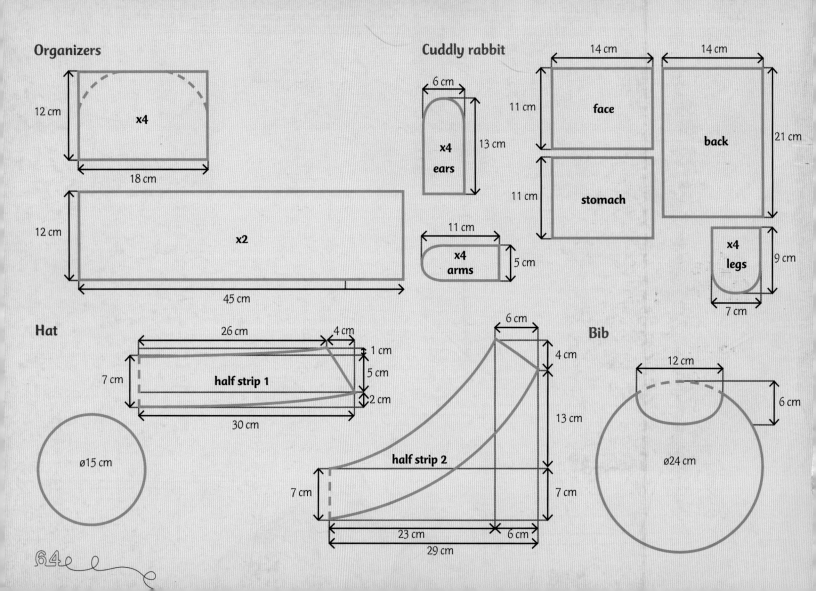

Organizers

x4
12 cm
18 cm

x2
12 cm
45 cm

Cuddly rabbit

6 cm
x4
ears
13 cm

11 cm
x4
arms

14 cm
face
11 cm

14 cm
back
21 cm

11 cm
stomach

x4
legs
9 cm
7 cm

Hat

26 cm
4 cm
7 cm
half strip 1
1 cm
5 cm
2 cm
30 cm

ø15 cm

6 cm
4 cm
13 cm
half strip 2
7 cm
7 cm
23 cm
6 cm
29 cm

Bib

12 cm
6 cm
ø24 cm

64